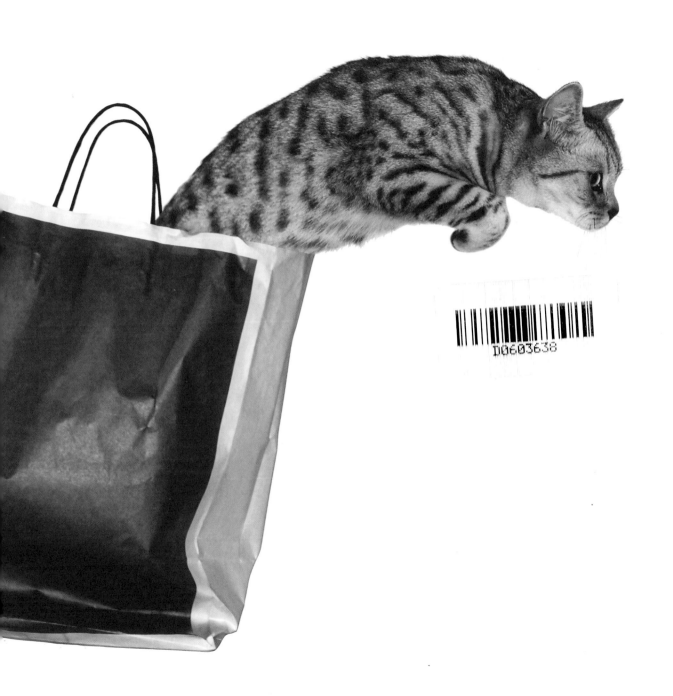

Meow

I Love Cats

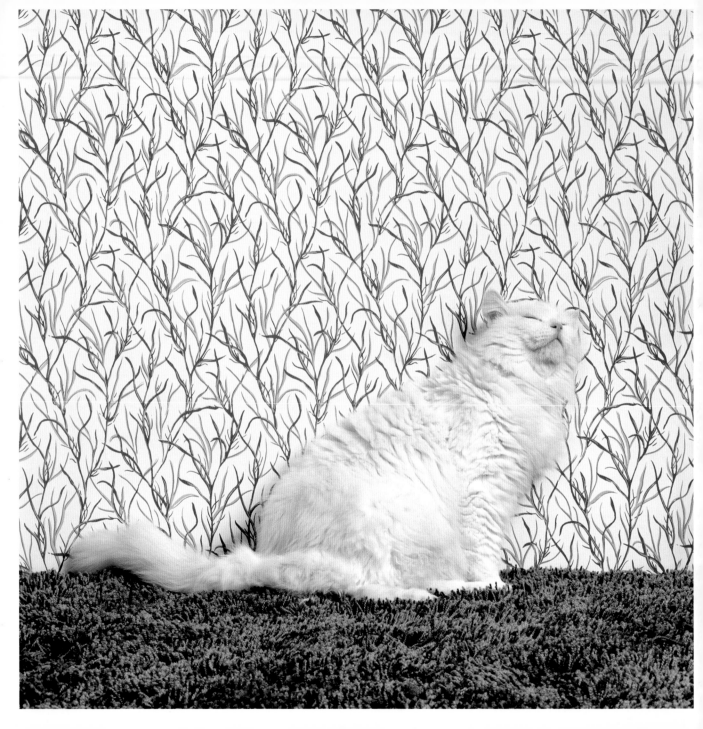

Meow

I Love Cats

Featuring images by
Rachael Hale McKenna, Catherine Ledner & Gandee Vasan

CHRONICLE BOOKS
SAN FRANCISCO

in association with PQ Blackwell

If you want to write, keep cats.

ALDOUS HUXLEY

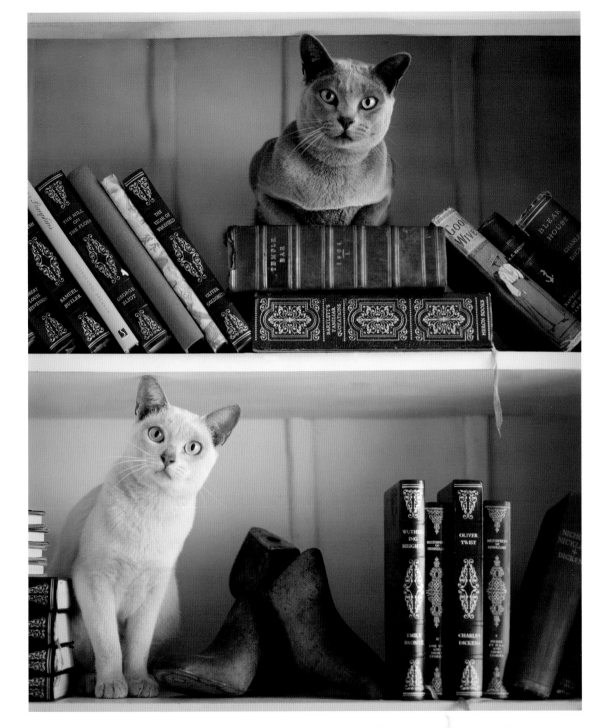

There's no need for a piece of
sculpture in a home that has a cat.

WESLEY BATES

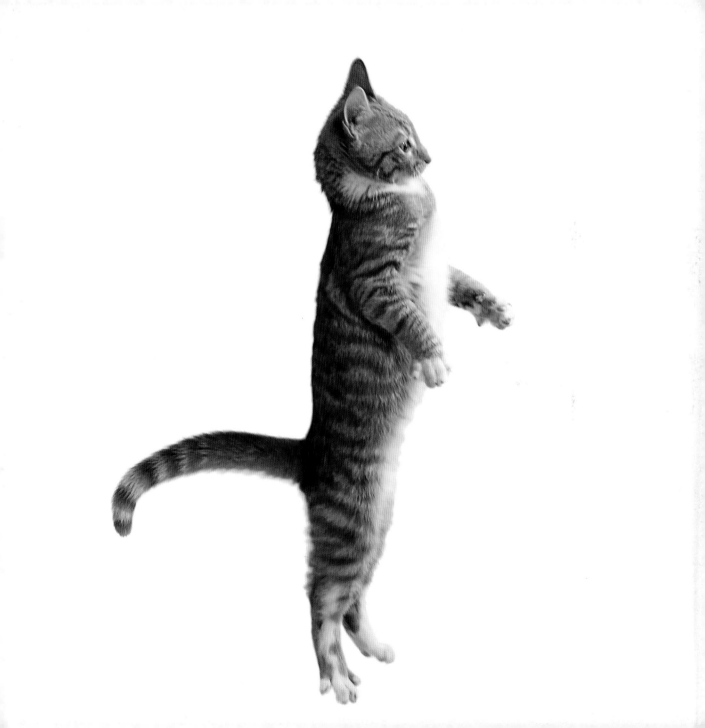

Prowling his own quiet backyard or asleep by the fire, he is still only a whisker away from the wilds.

JEAN BURDEN

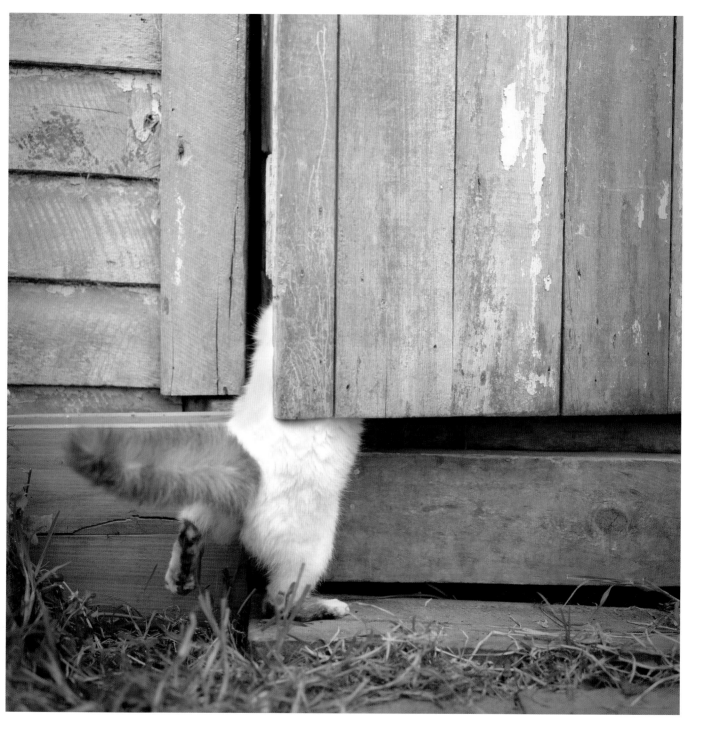

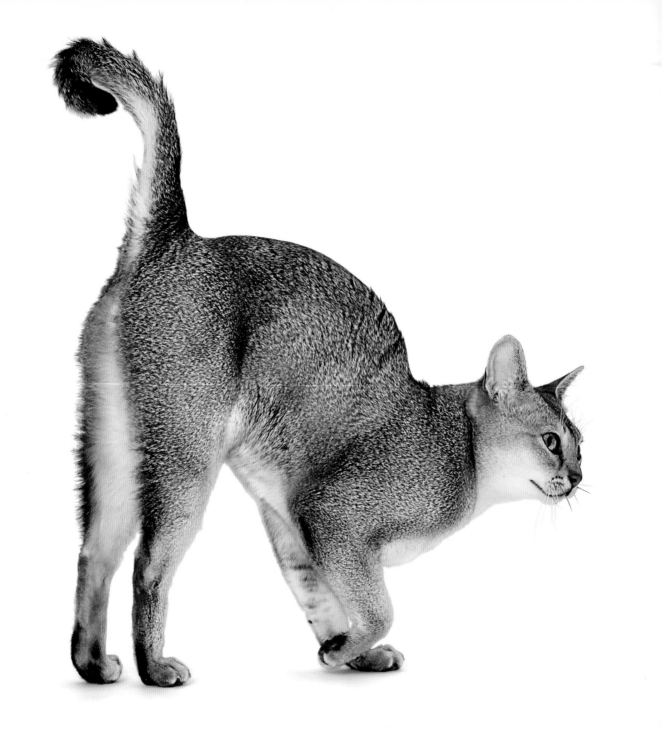

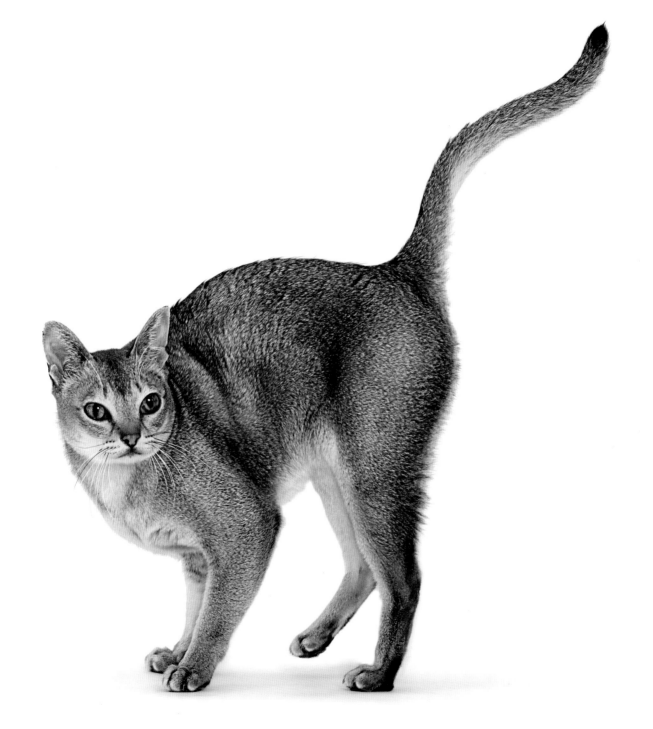

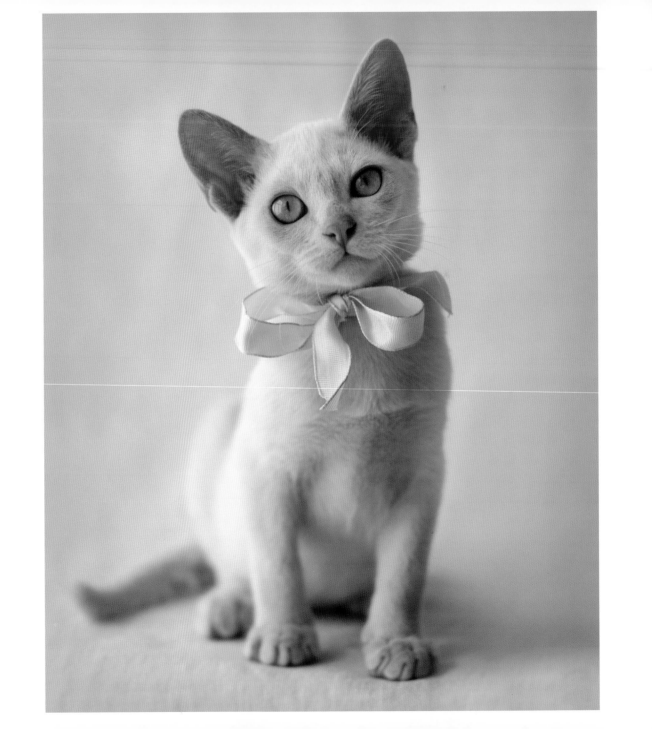

The smallest feline is a masterpiece.

LEONARDO DA VINCI

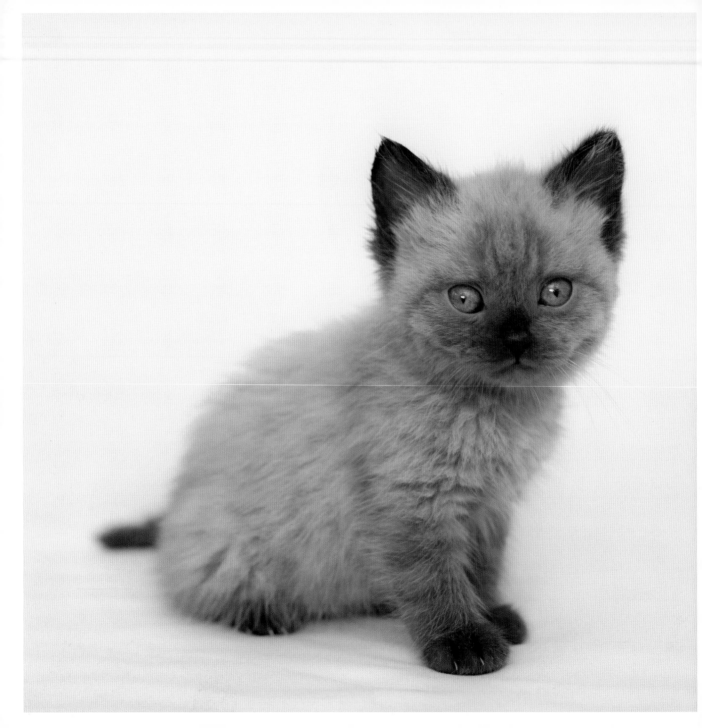

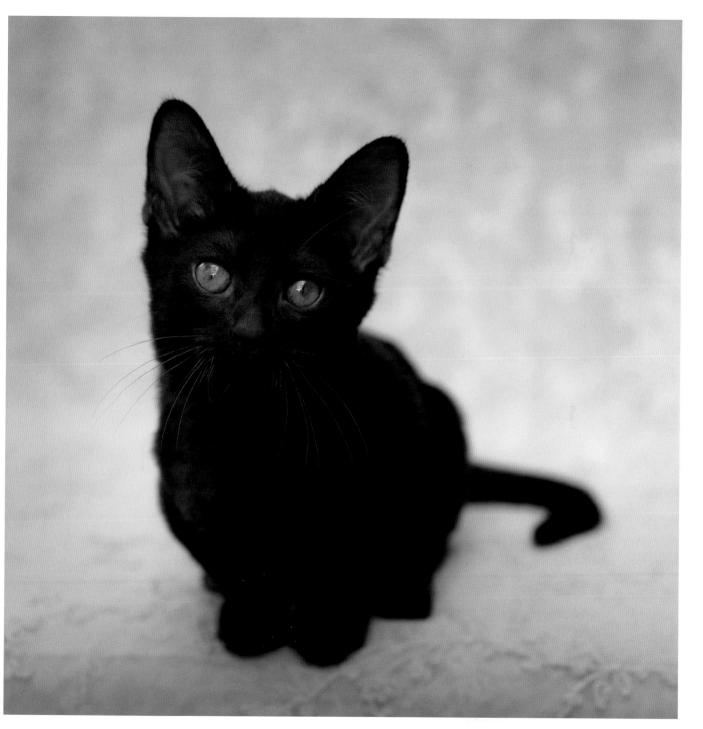

A kitten is chiefly remarkable
for rushing like mad at nothing
whatever, and generally stopping
before it gets there.

AGNES REPPLIER

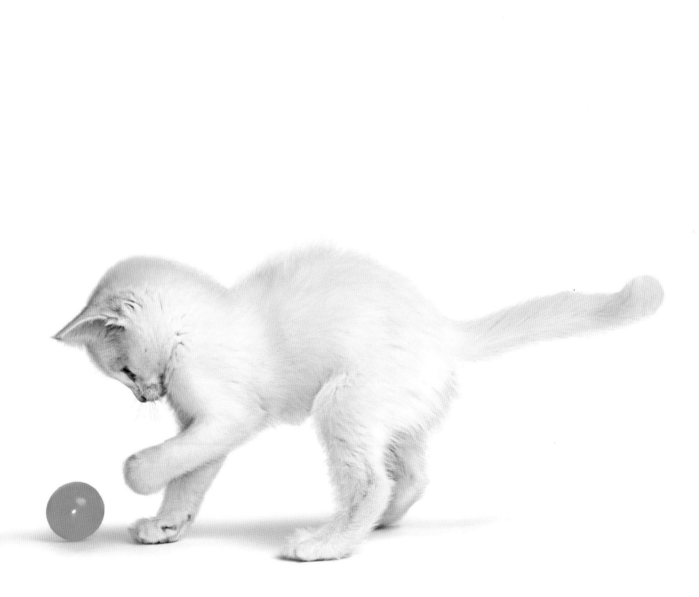

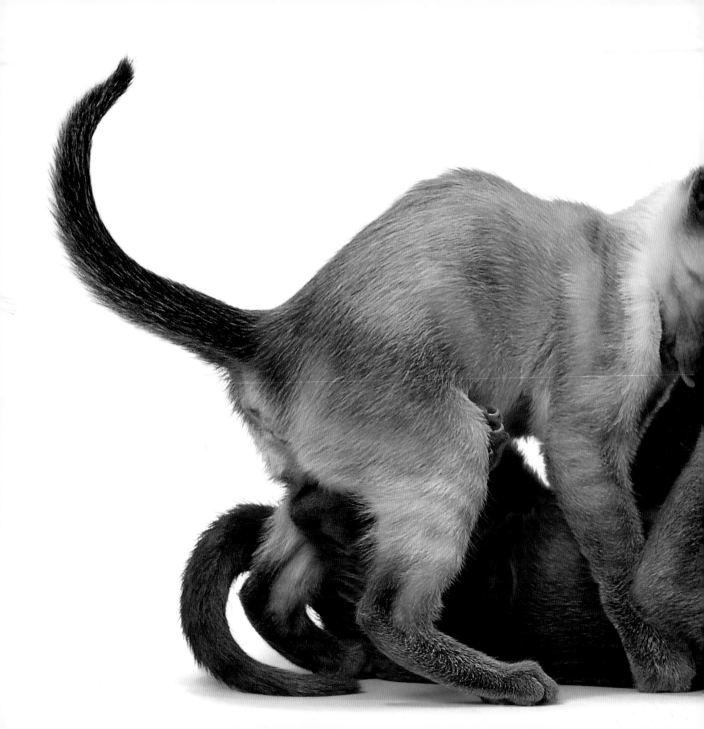

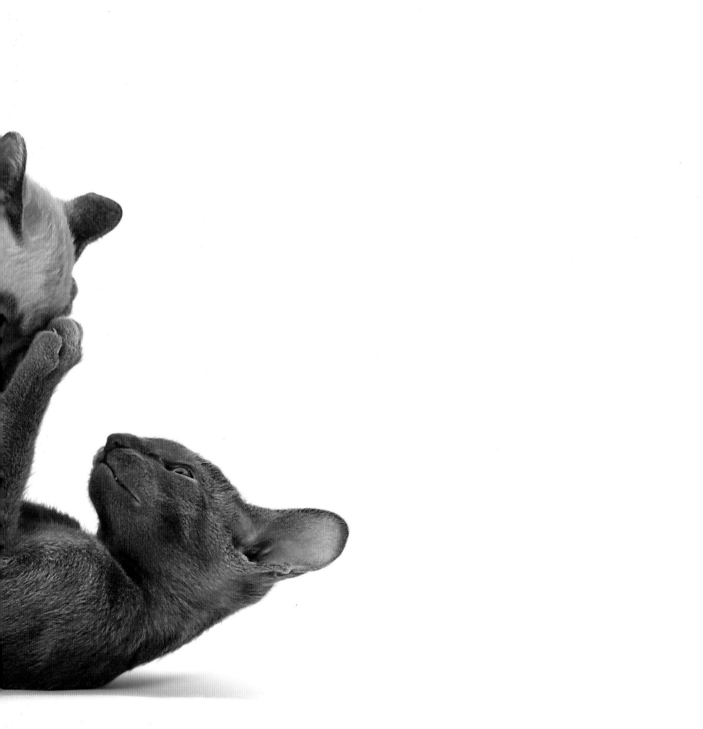

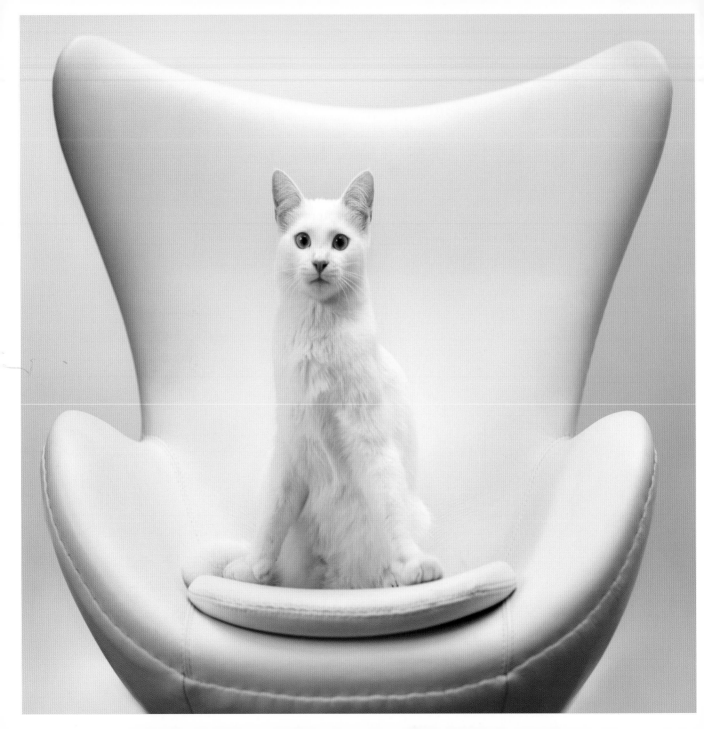

Dogs believe they are human.

Cats believe they are God.

ANON

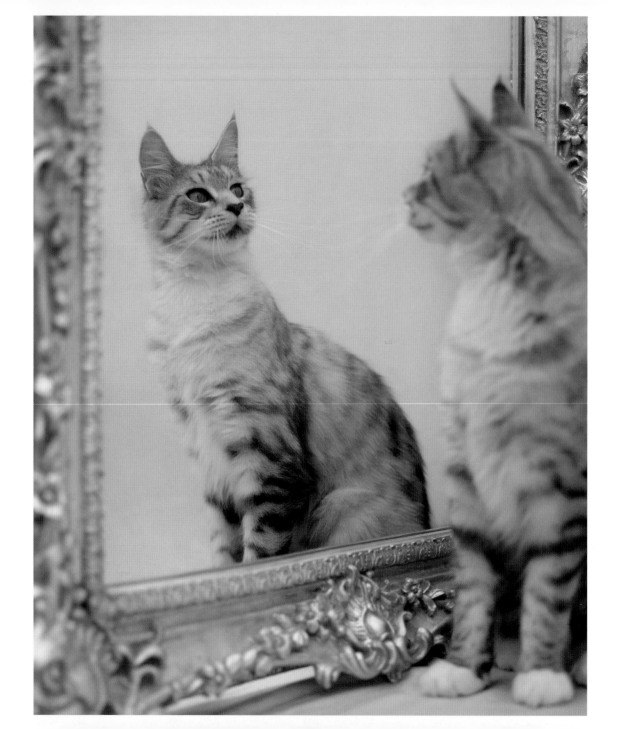

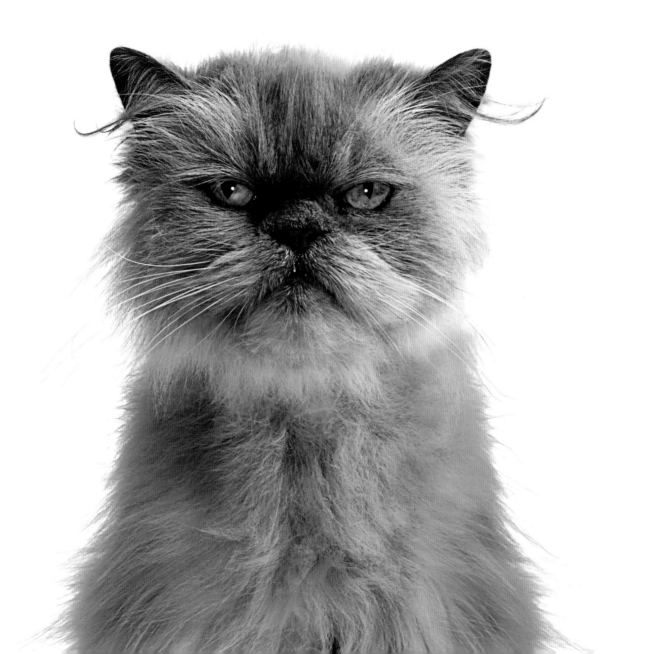

Cats are like supermodels—they

never strike an unattractive pose.

ANON

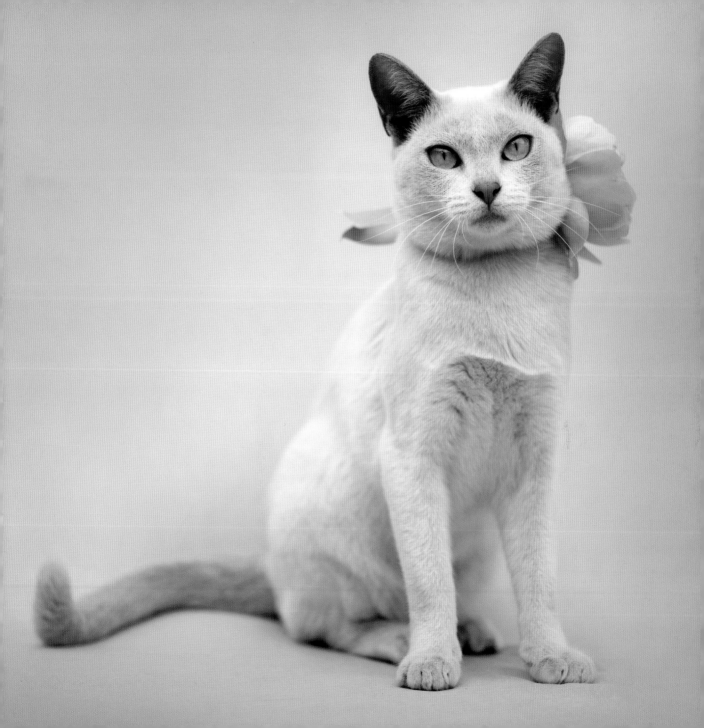

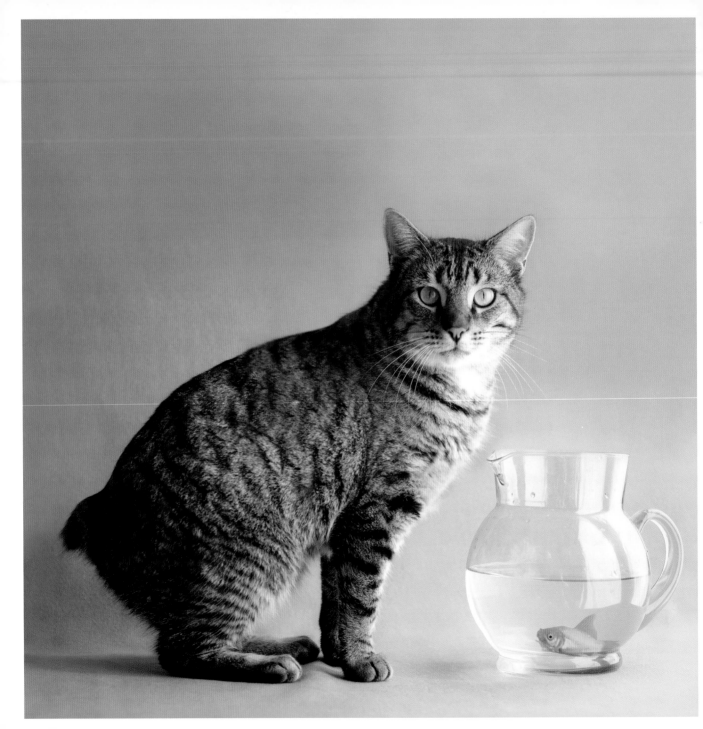

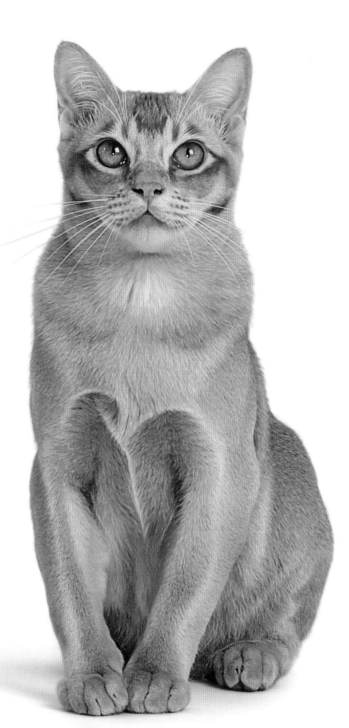

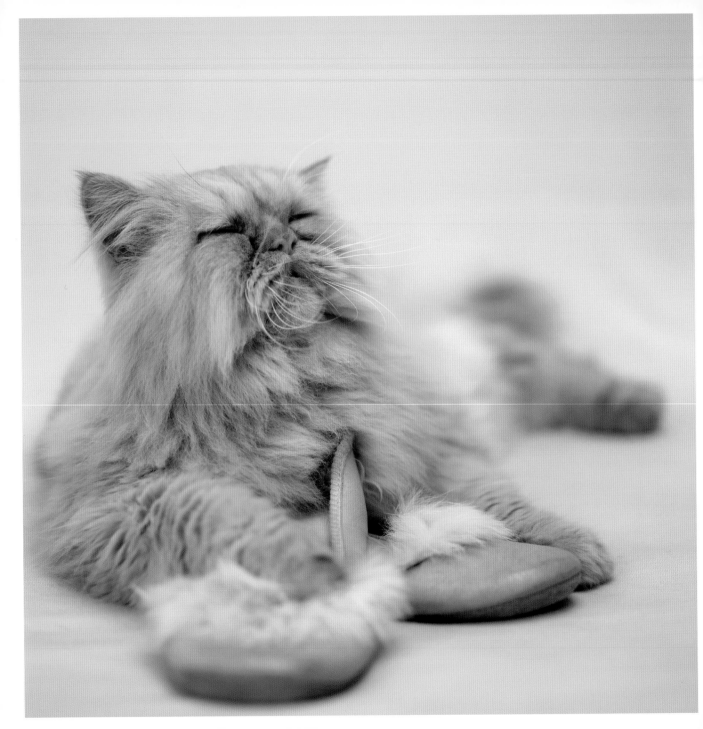

No amount of time can erase

the memory of a good cat,

and no amount of masking tape

can ever totally remove his

fur from your couch.

LEO DWORKEN

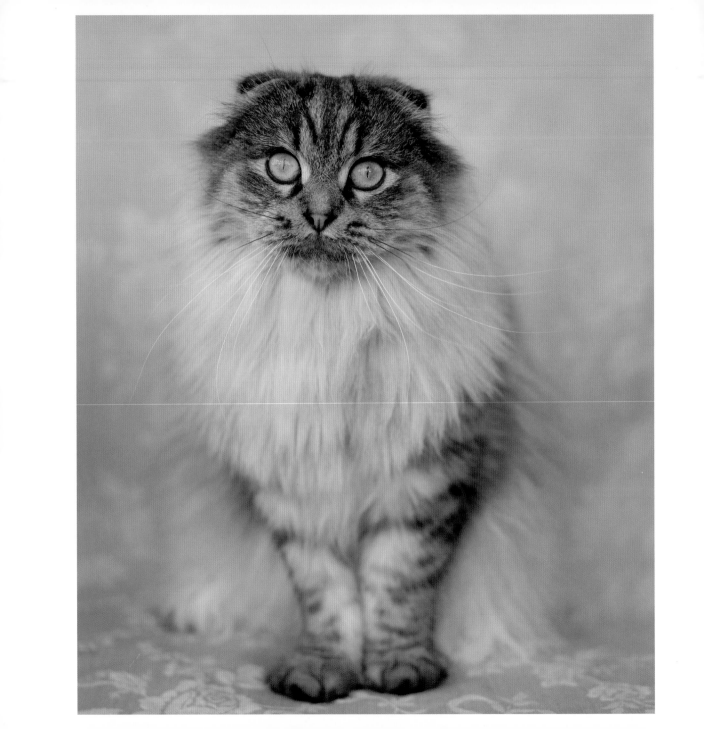

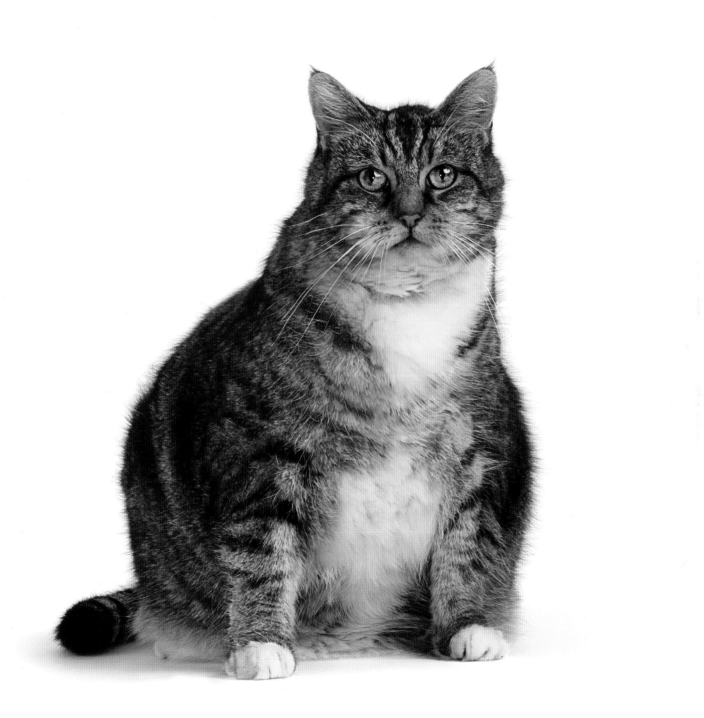

One of the ways in which cats show happiness is by sleeping.

CLEVELAND AMORY

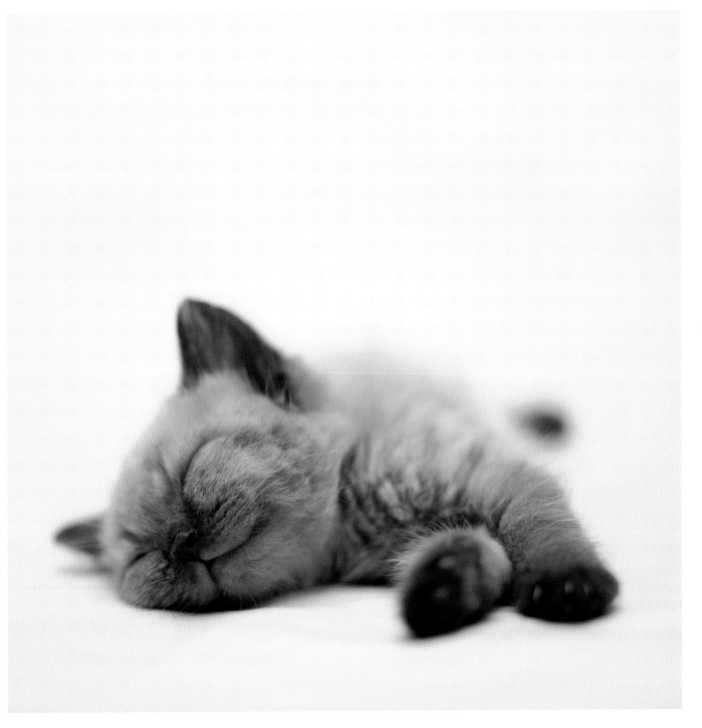

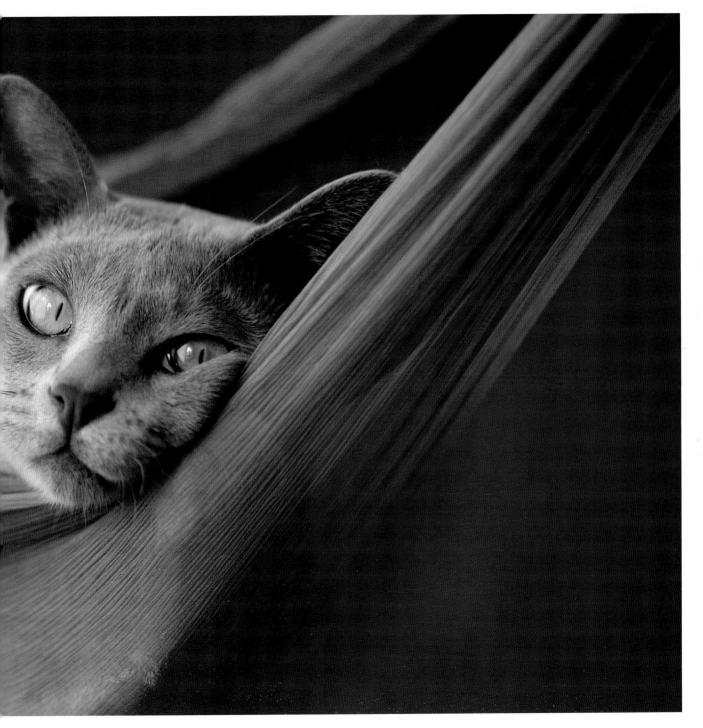

Cats are rather delicate creatures and they
are subject to a good many ailments, but I've
never heard of one who suffered from insomnia.

JOSEPH WOOD KRUTCH

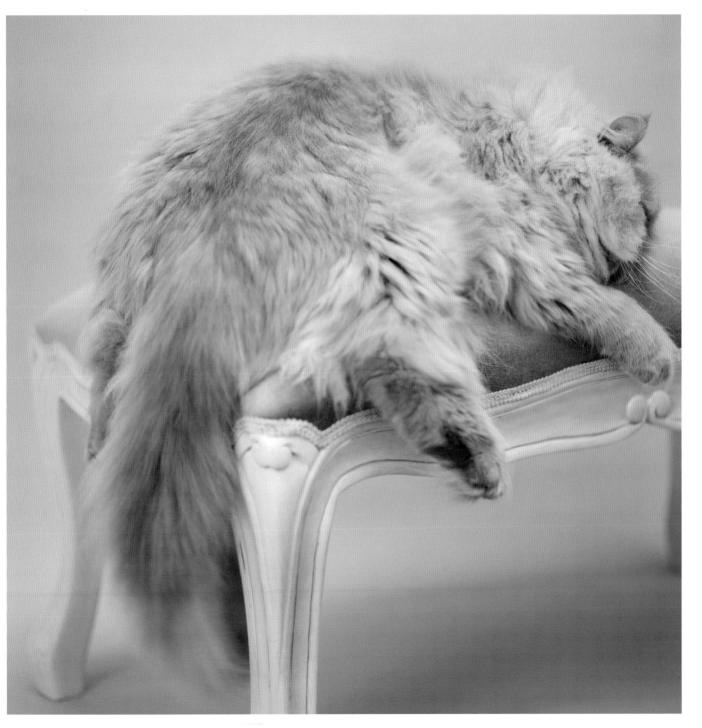

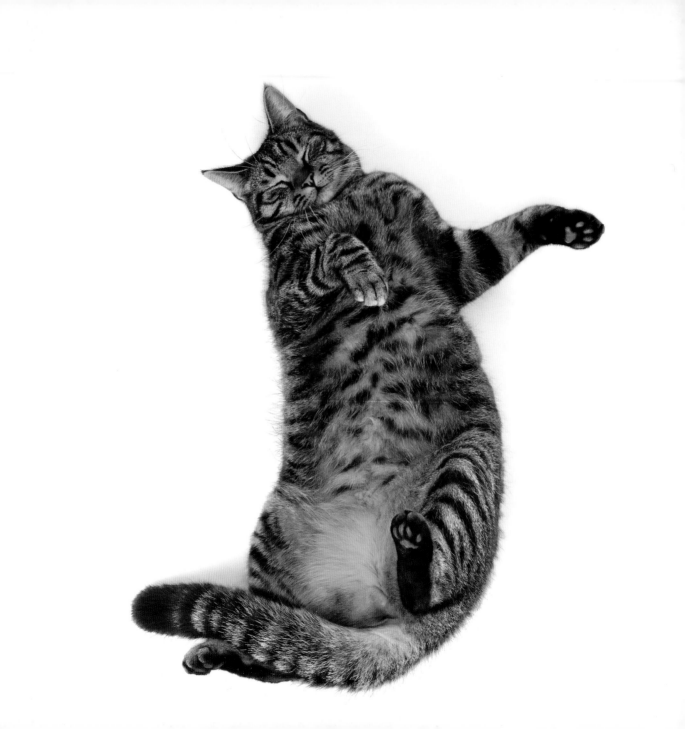

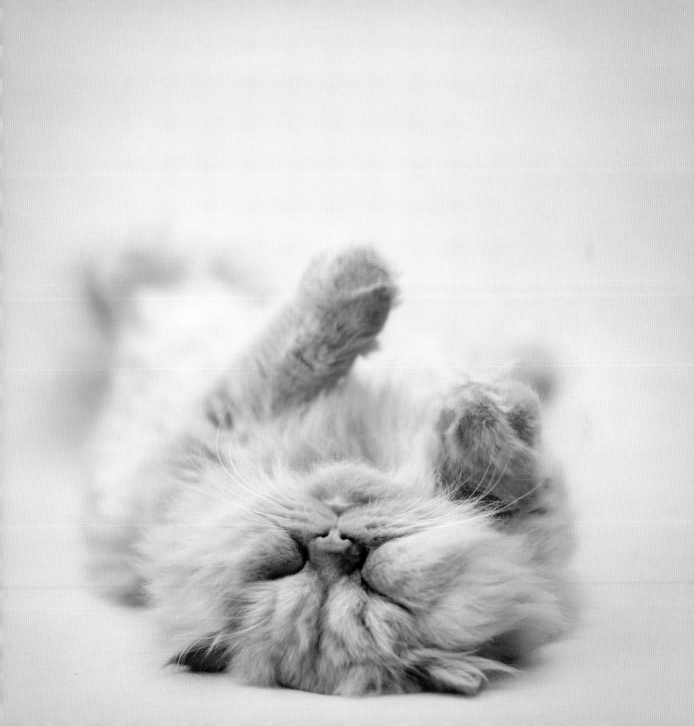

Cat: A pygmy lion who loves mice, hates dogs,

and patronizes human beings.

OLIVER HERFORD

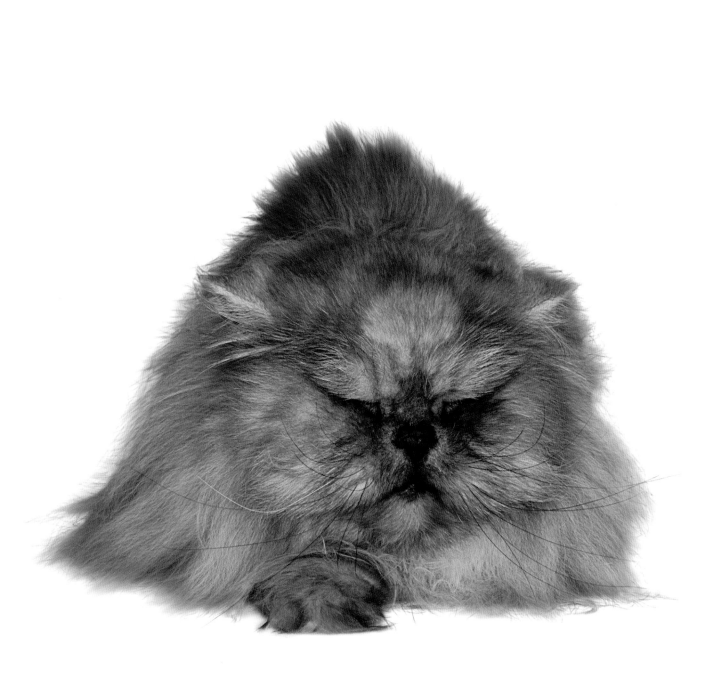

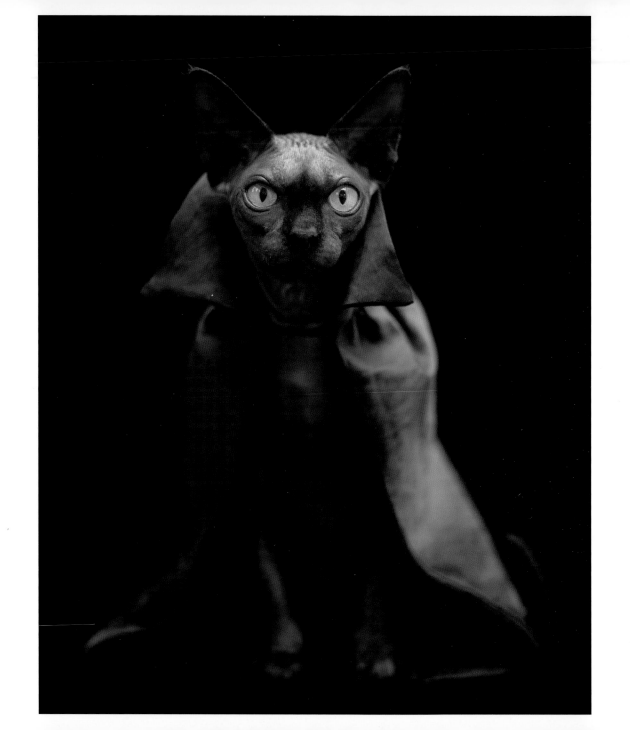

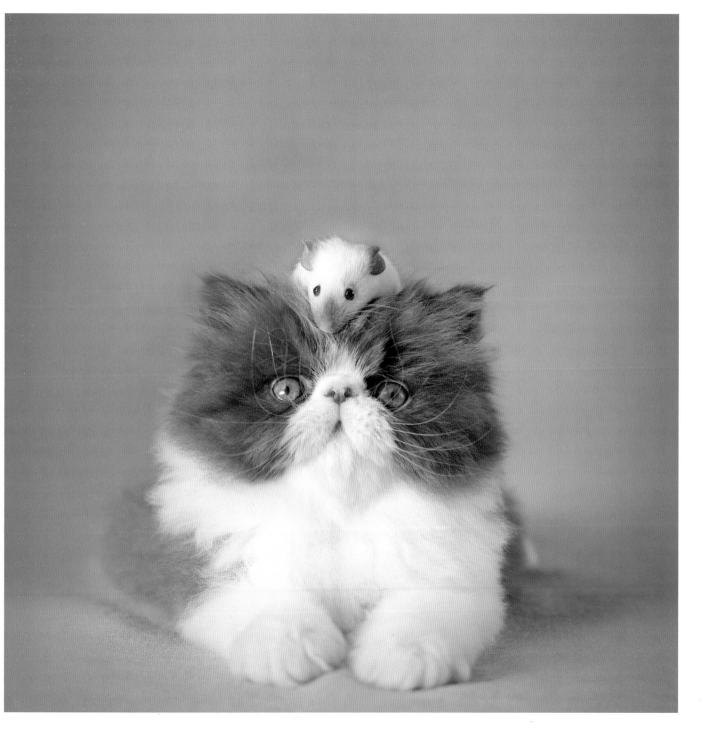

To bathe a cat takes

brute force, perseverance,

courage of conviction—and a cat.

The last ingredient is usually

hardest to come by.

STEPHEN BAKER

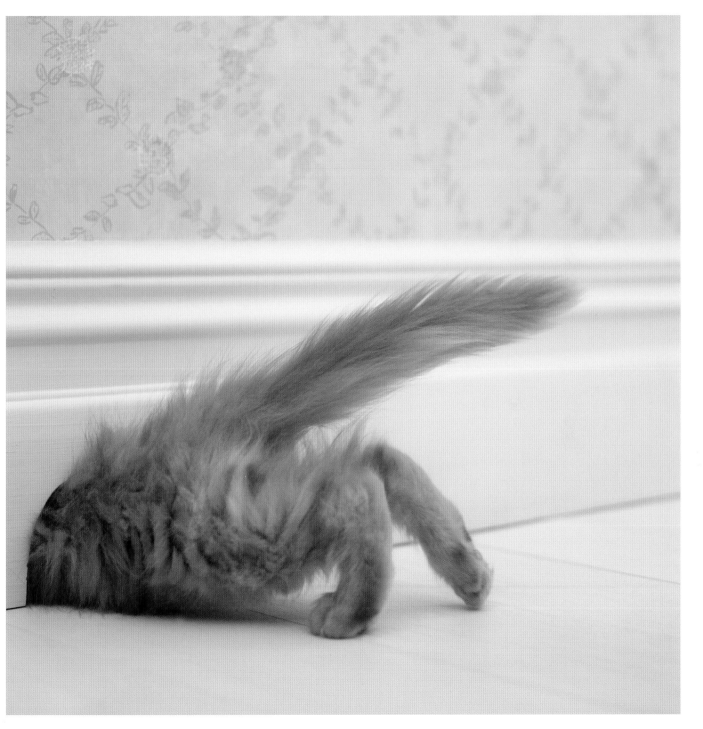

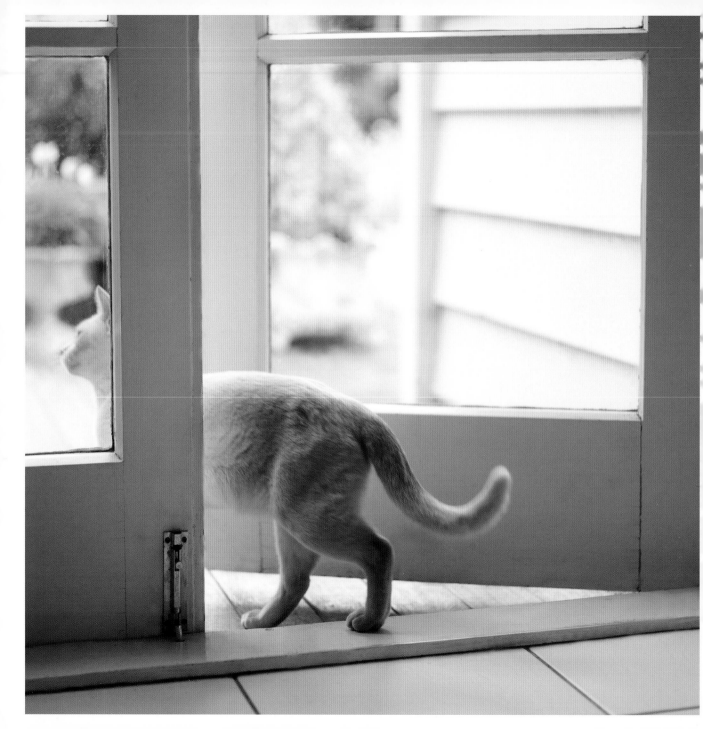

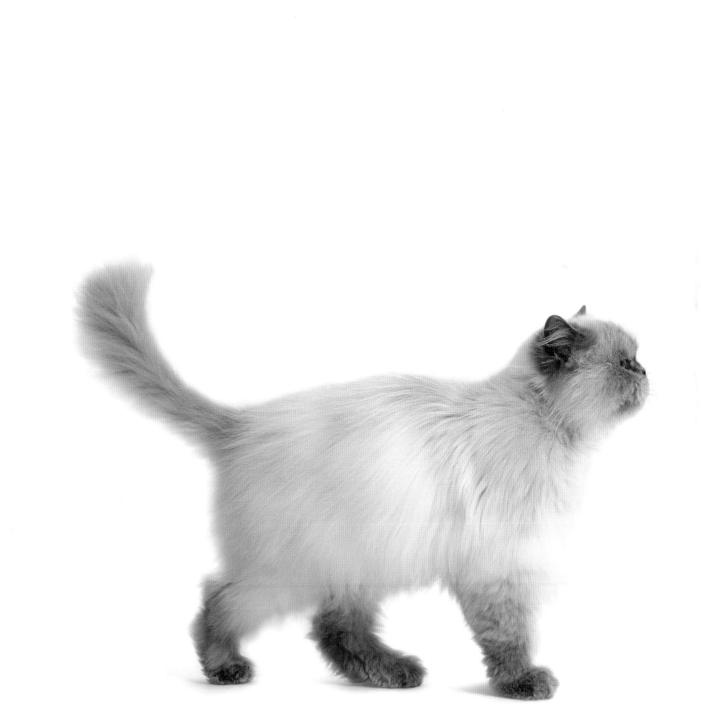

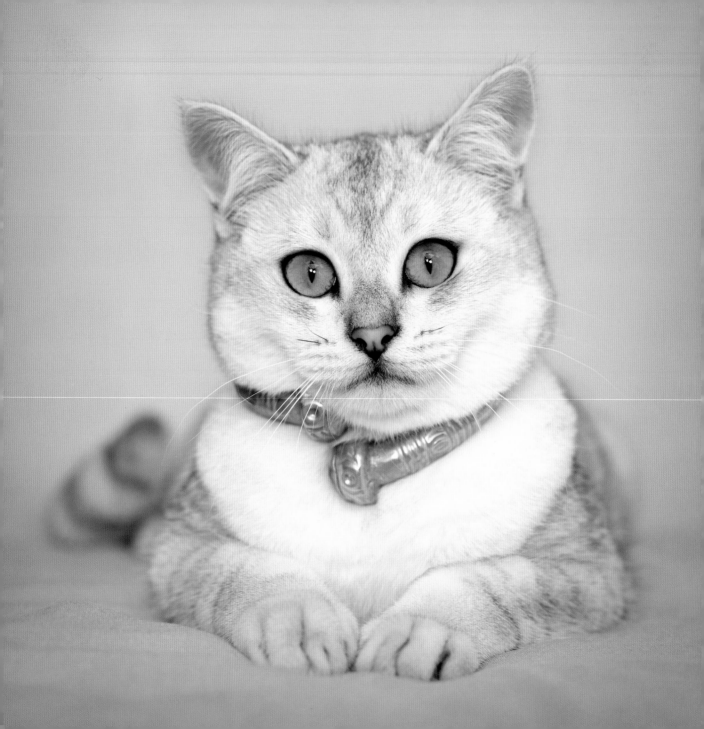

It is with the approach

of winter that cats

wear their richest fur and

assume an air of sumptuous

and delightful opulence.

PIERRE LOTI

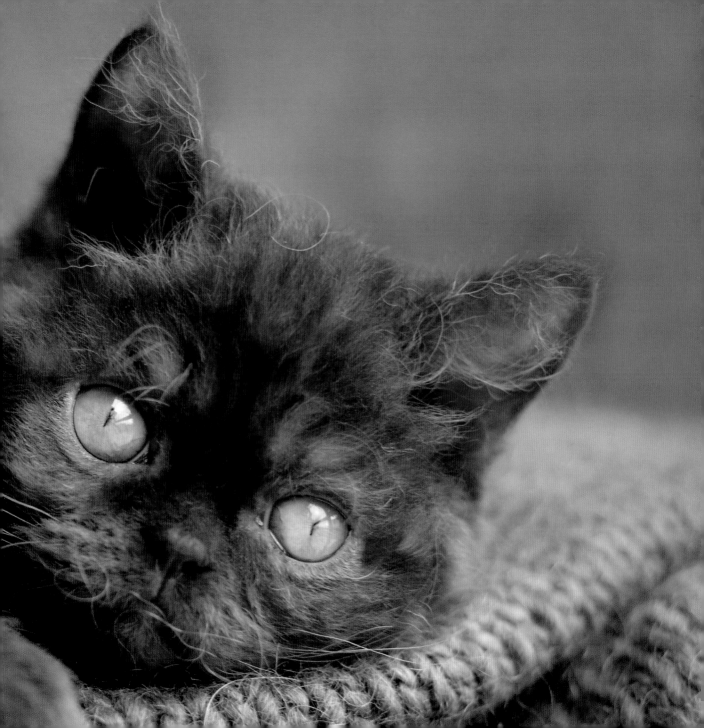

It is impossible to keep a straight face in the presence of one or more kittens.

CYNTHIA E VARNADO

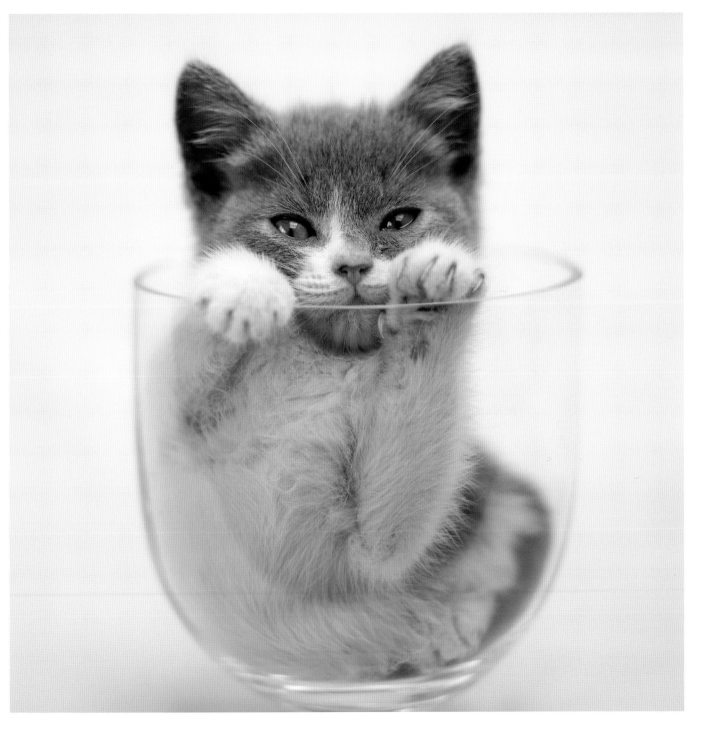

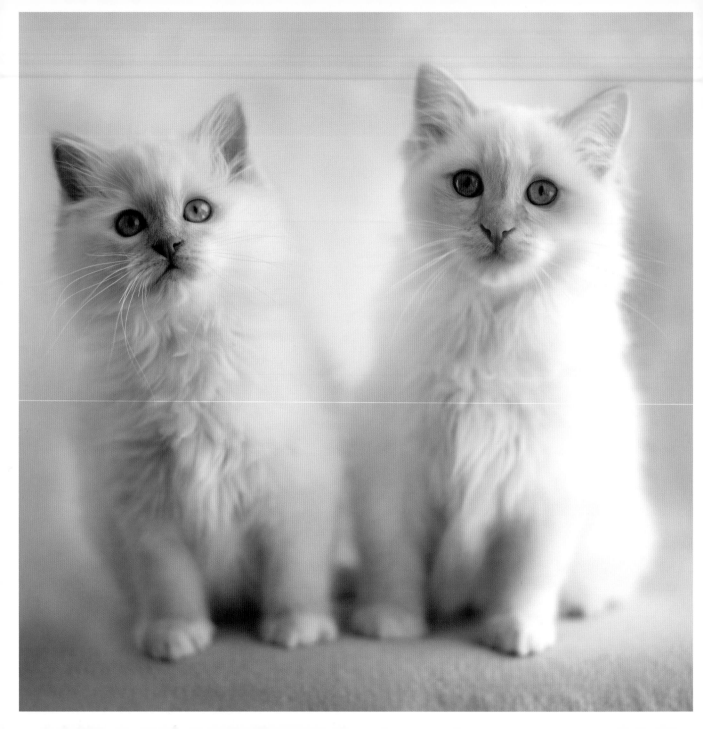

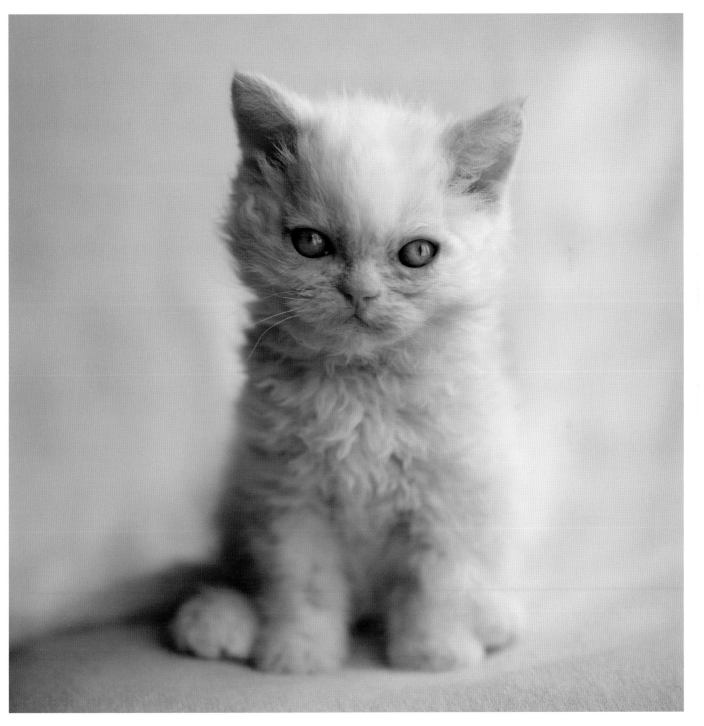

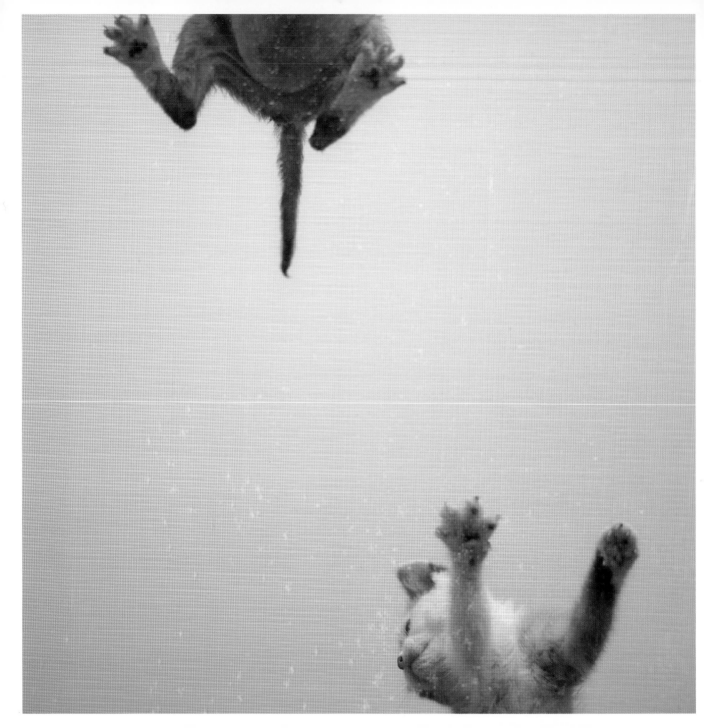

It's kind of fun to do the impossible.

WALT DISNEY

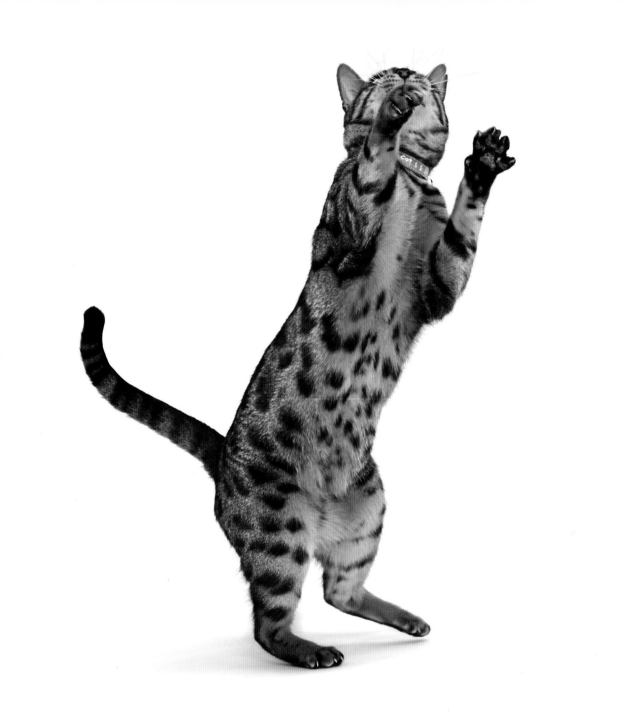

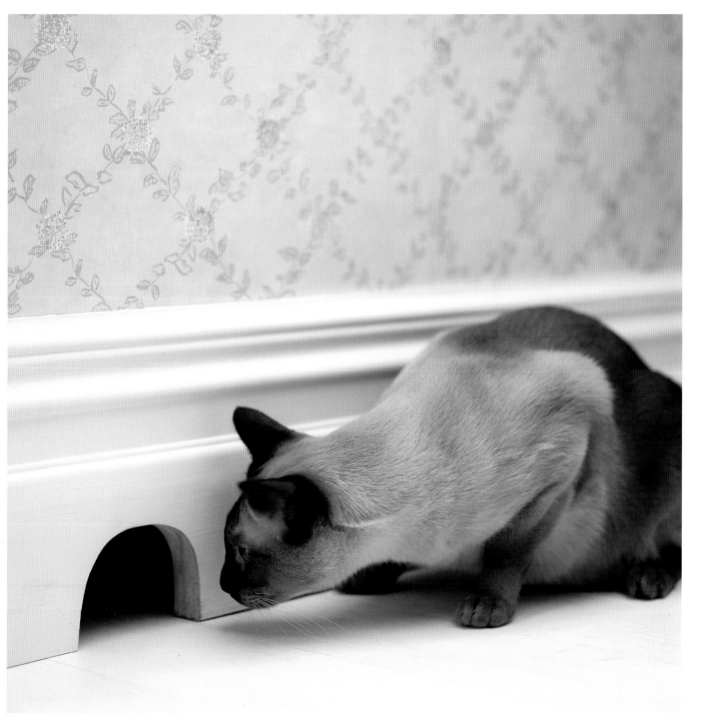

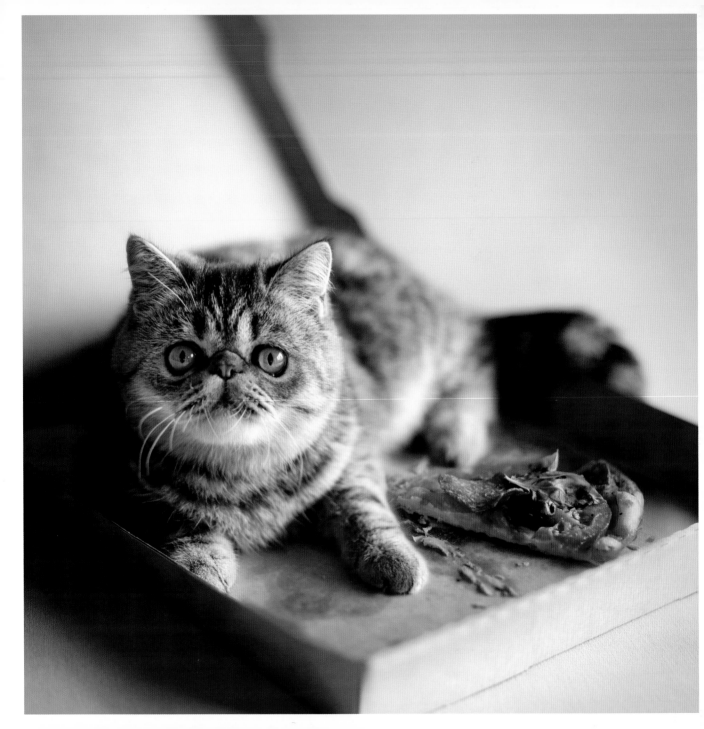

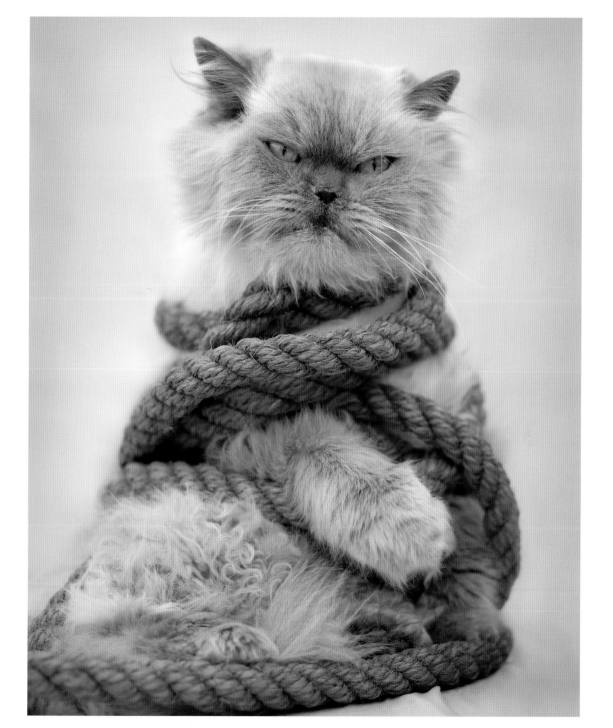

Cats are connoisseurs of comfort.

JAMES HERRIOT

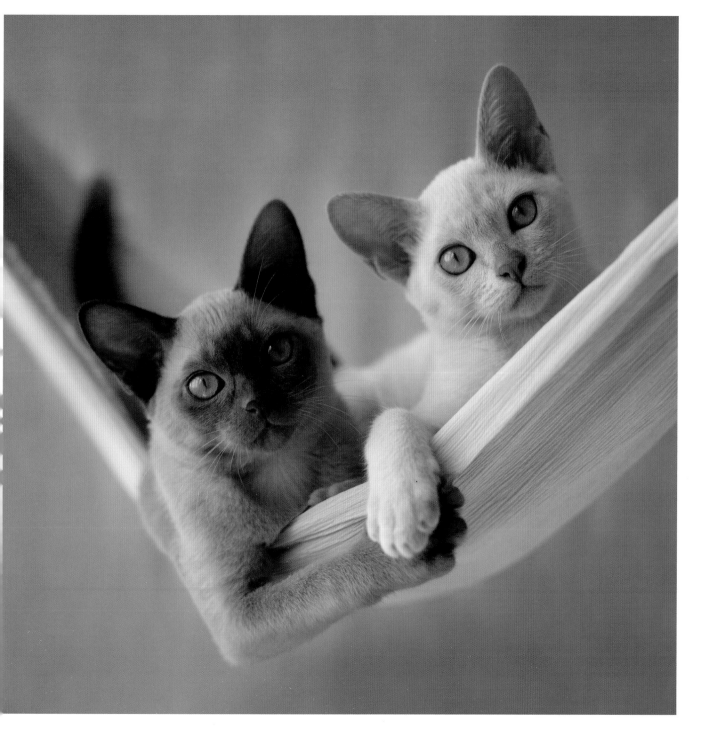

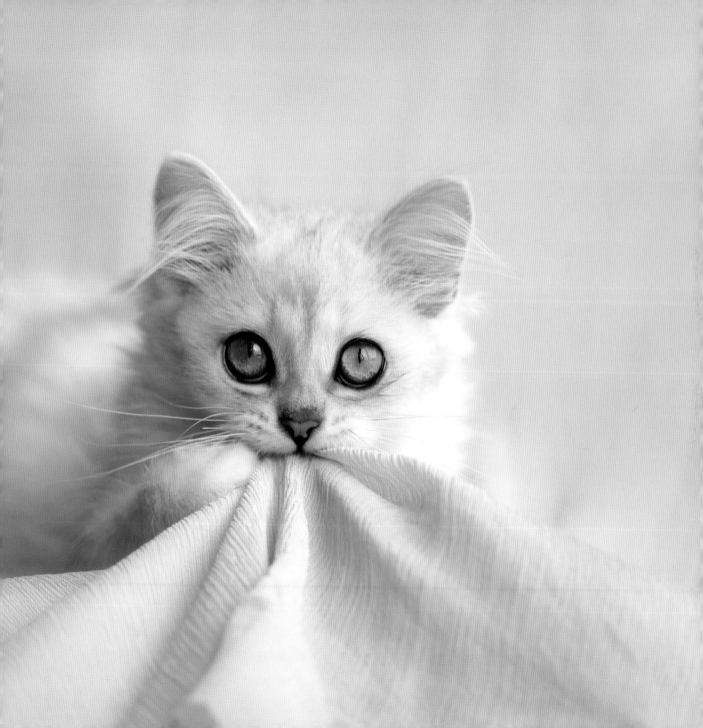

If man could be crossed with the
cat, it would improve man, but
it would deteriorate the cat.

MARK TWAIN

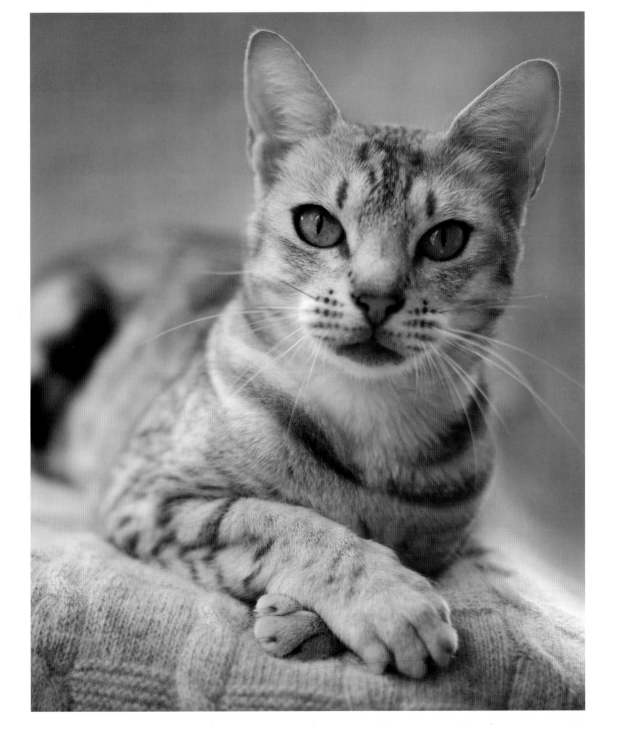

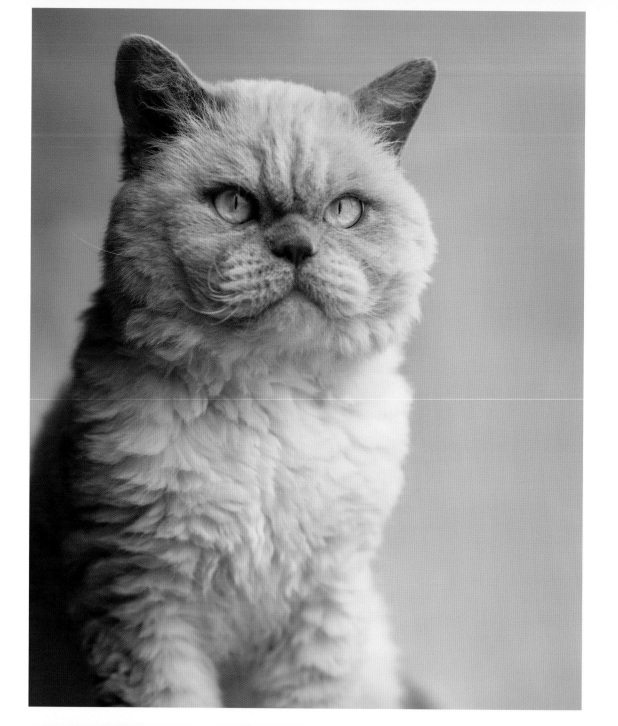

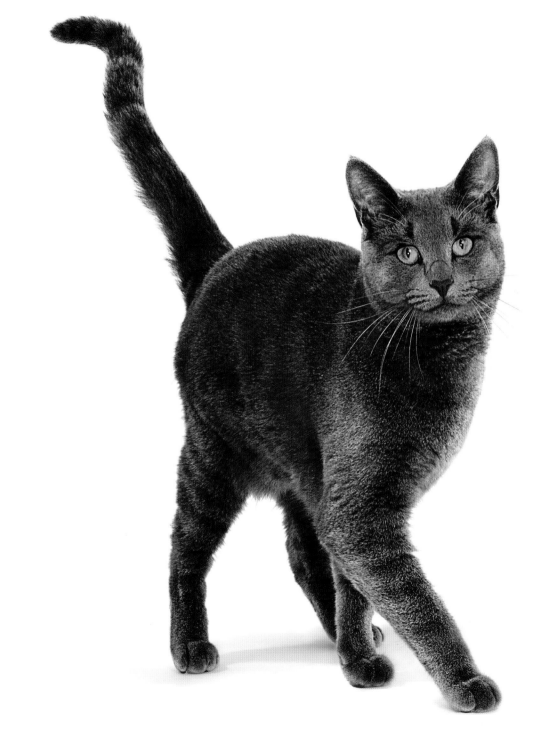

When she walked she stretched out
long and thin like a little tiger, and held
her head high to look over the grass
as if she were treading the jungle.

SARAH ORNE JEWETT

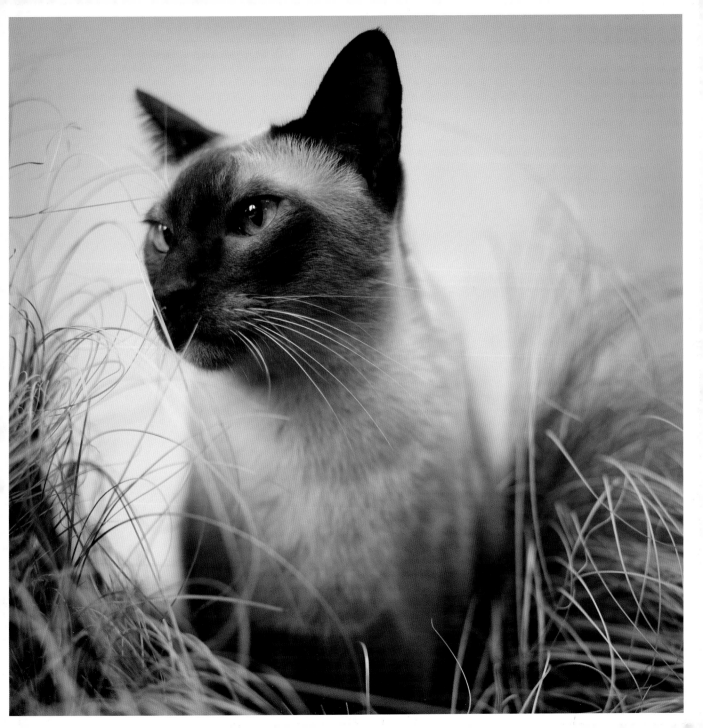

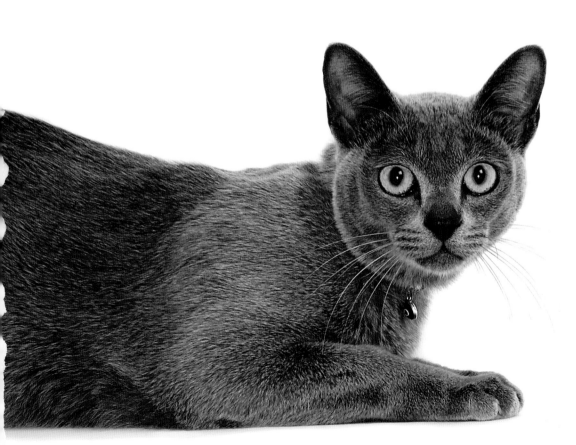

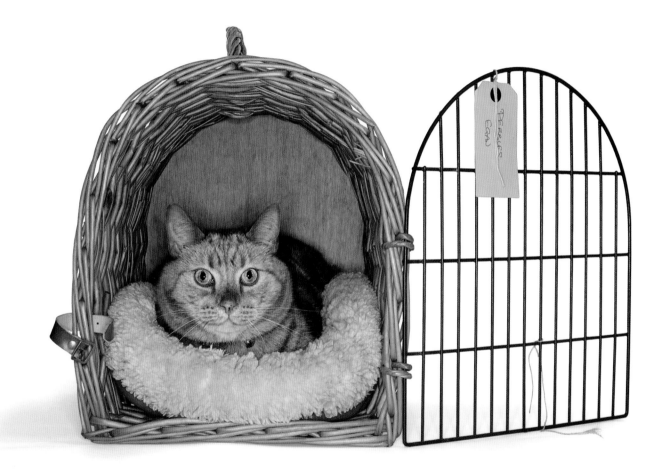

Even a cat is a lion in her own lair.

INDIAN PROVERB

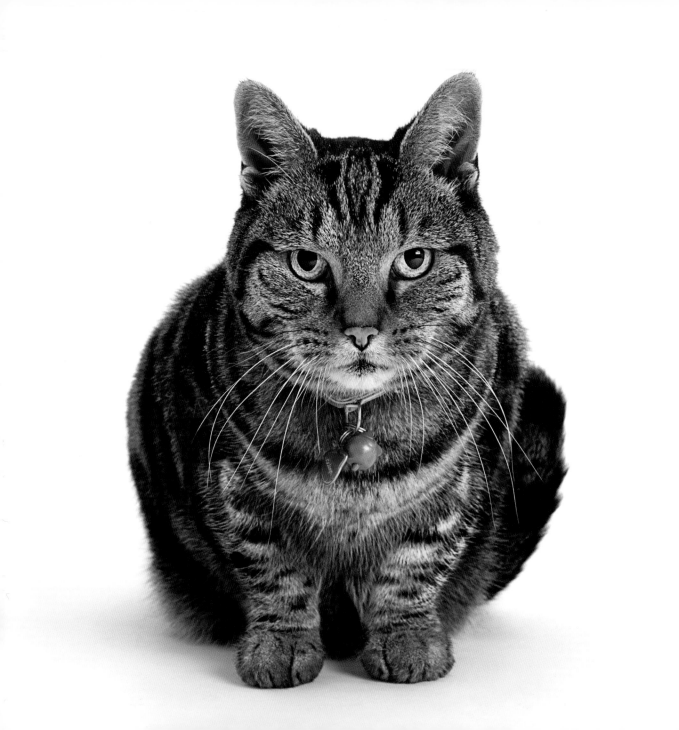

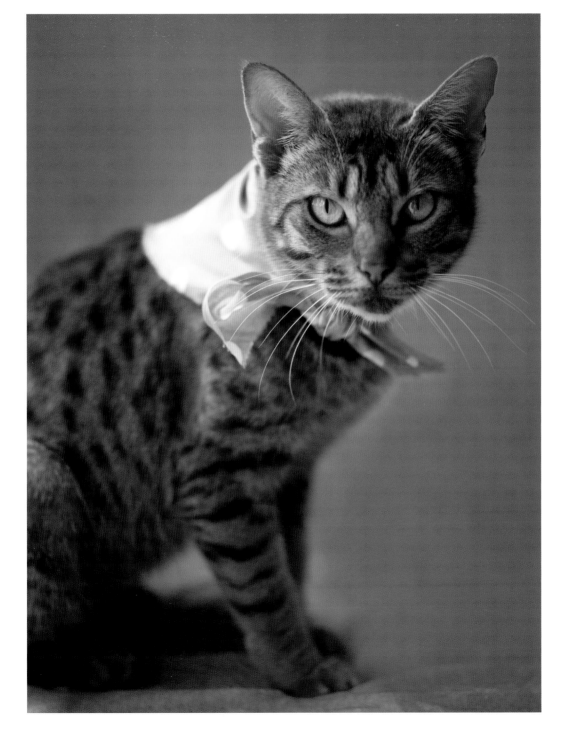

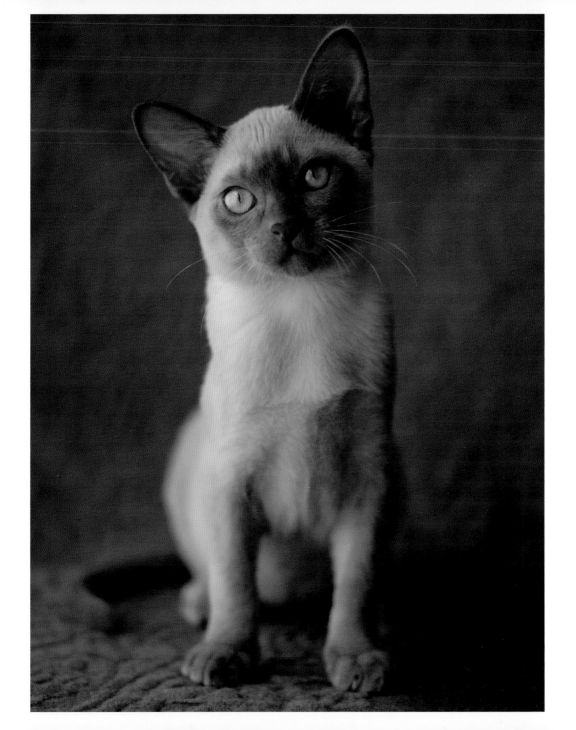

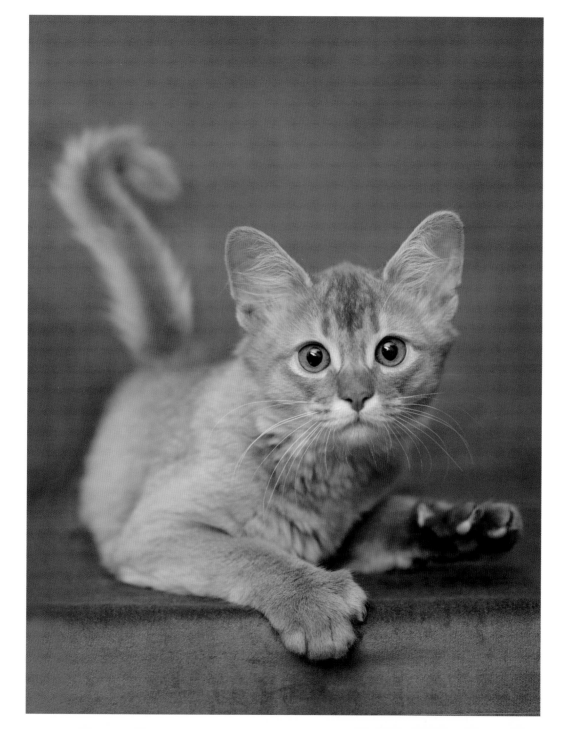

Thou art the Great Cat,

the avenger of the gods,

and the judge of words,

and the president of the sovereign chiefs

and the governor of the holy circle;

thou art indeed the Great Cat.

INSCRIPTION ON THE ROYAL TOMBS AT THEBES

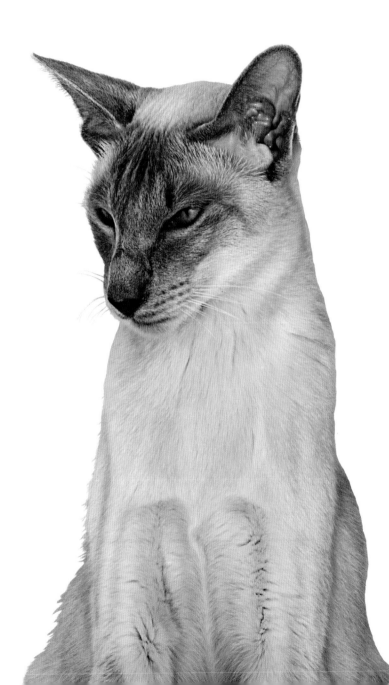

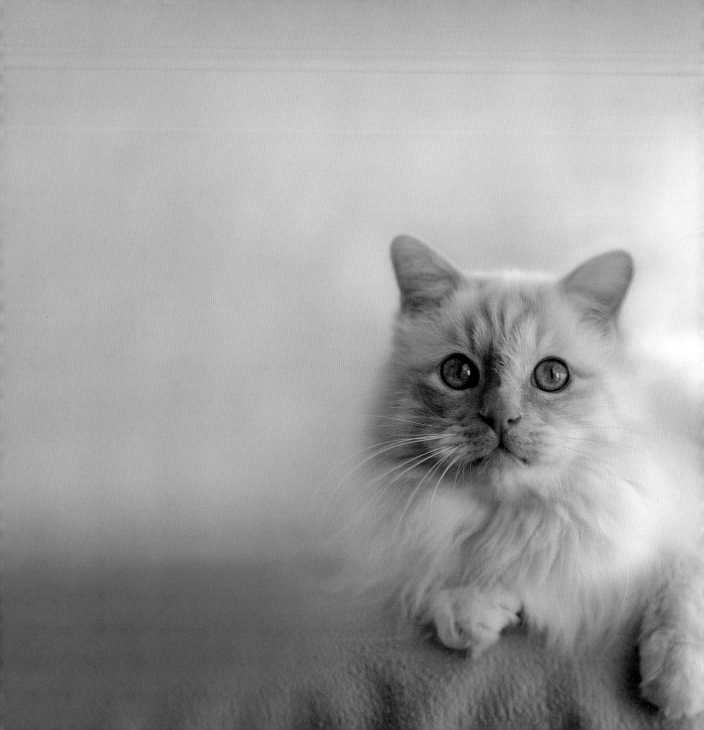

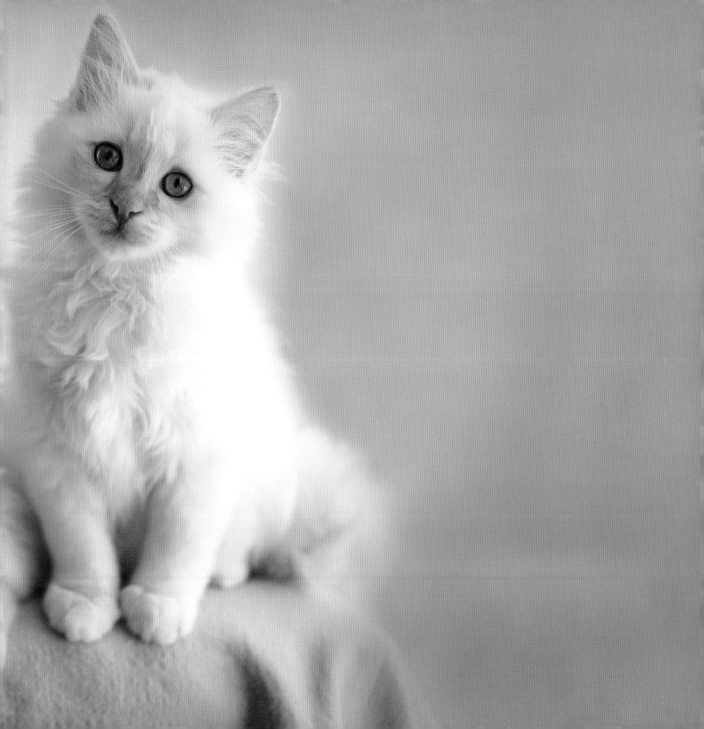

Catherine Ledner's work is highly sought after and has appeared in numerous publications including *Travel + Leisure*, *Dwell* and the *New York Times Magazine*.

Rachael McKenna is one of the world's most popular animal photographers, and her books, published under her maiden name of Rachael Hale, have sold over 2.7 million copies.

Gandee Vasan is an award-winning photographer whose images have been exhibited at the National Portrait Gallery in London.

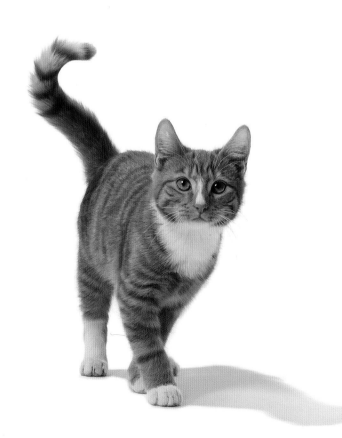

First published in the United States in 2011 by Chronicle Books LLC.

Compilation copyright © 2011 PQ Blackwell Limited
Book design by Sarah Anderson

Images are copyright the individual photographers as follows: front cover, back cover and pp. 5, 9, 12, 14, 15, 20, 22, 24–25, 26, 28, 30, 33, 34–35, 37, 39, 42, 43, 45, 46, 48, 50–51, 53, 54, 55, 56, 59, 60, 61, 63, 64–65, 67, 68, 71, 77, 78, 79 and 82–83 copyright © Rachael Hale Trust; p. 2 copyright © Catherine Ledner; endpapers and pp. 7, 10, 11, 17, 18–19, 23, 27, 31, 38, 41, 47, 58, 69, 72–73, 74, 76, 81 and 84 copyright © Gandee Vasan.

The publisher is grateful for literary permissions to reproduce items subject to copyright. Every effort has been made to trace the copyright holders and the publisher apologizes for any unintentional omission. We would be pleased to hear from any not acknowledged and undertake to make all reasonable efforts to include the appropriate acknowledgment in any subsequent editions.

"One of the ways in which cats show happiness is by sleeping" from *The Cat Who Came For Christmas* by Cleveland Amory, copyright © 1987 Cleveland Amory. Used by permission of Little, Brown and Company. "There's no need for a piece of sculpture in a home that has a cat" used with permission of Wesley Bates. "Cats are connoisseurs of comfort" from *James Herriot's Cat Stories* by James Herriot, published by Michael Joseph (UK) and St. Martin's Press (US). Reprinted with permission of David Higham Associates.

Library of Congress Cataloging-in-Publication Data available.

ISBN: 978-1-4521-0169-9

Manufactured in China

Produced and originated by PQ Blackwell Limited
116 Symonds Street, Auckland, New Zealand
www.pqblackwell.com

10 9 8 7 6 5 4 3 2

Chronicle Books LLC
680 Second Street
San Francisco, CA 94107
www.chroniclebooks.com

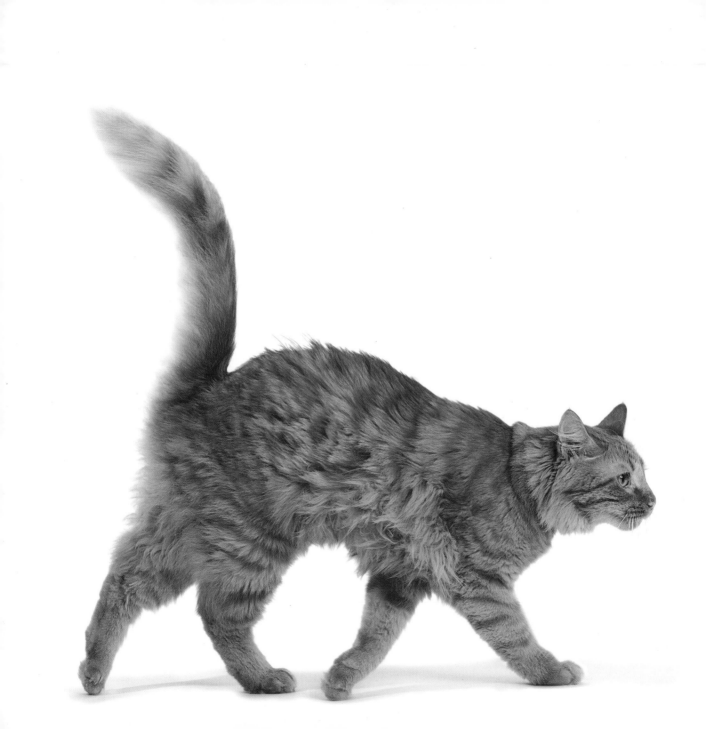